Edouard Manet

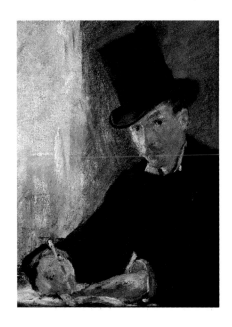

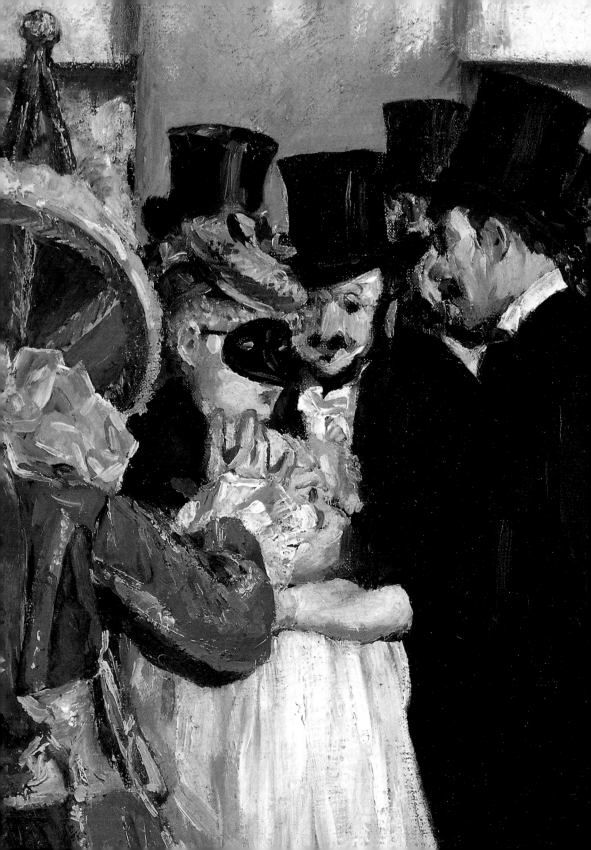

GREAT ARTISTS

Edouard Manet

RICHARD WRIGLEY

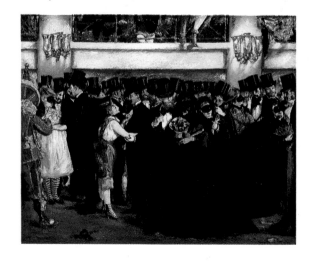

SCALA BOOKS

Text © Richard Wrigley 1991
© Scala Publications Ltd and Réunion
des Musées Nationaux 1992

First published 1992
by Scala Publications Limited
3 Greek Street
London W1V 6NX

in association with
Réunion des Musées Nationaux
49 Rue Etienne Marcel
Paris 75039

Distributed in the USA and Canada by
Rizzoli International Publications, Inc
300 Park Avenue South
New York
NY 10010

ISBN 1 85759 001 5

Designed by Roger Davies
Edited by Paul Holberton
Produced by Scala Publications Ltd
Filmset by August Filmsetting,
St Helens, England
Printed and bound in Italy by
Graphicom, Vicenza

Photo credits: Artothek 15, 26;
Bridgeman 10, 20;
© RMN 1, 2, 6, 12, 13, 14, 16, 23, 25,
27

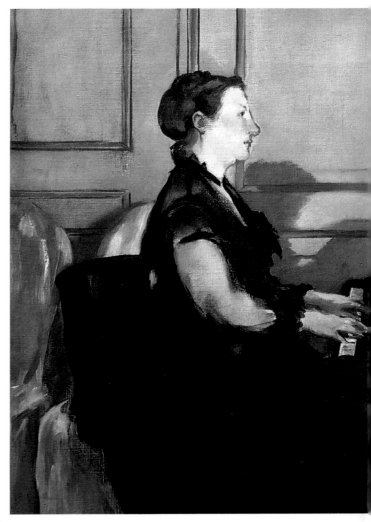

FRONTISPIECE Detail of **30**, *Man in a
café*
TITLEPAGE Whole and detail of **22**,
*Masked ball at the Opéra with
Punchinello*

1 Edouard Manet
Mme Manet at the piano, 1867–68
Oil on canvas, 38 × 46 cm
Paris, Musée d'Orsay

Contents

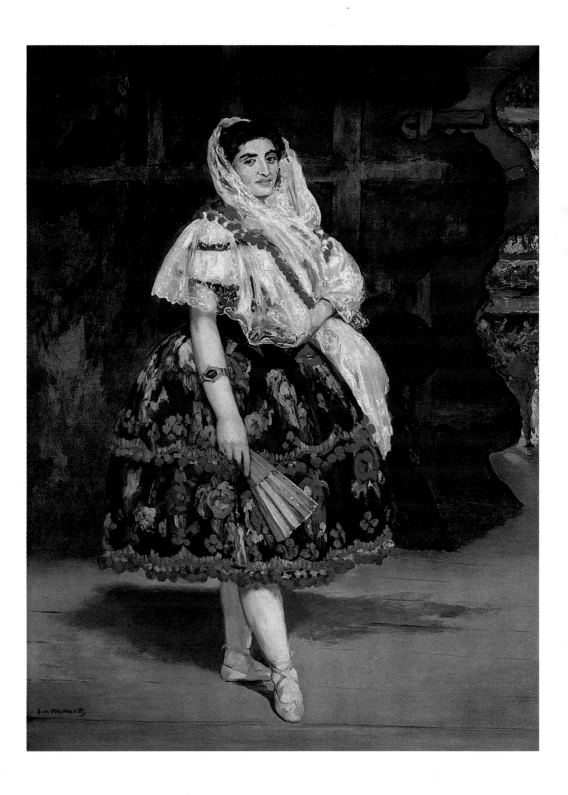

Introduction

Of all the artists of the modern era, Edouard Manet is at once one of the most familiar and elusive. His pictures are unfailingly compelling, but it has become difficult to make sense of them as part of history because Manet has been turned into a mythic "master of modern art". Furthermore, he plays a major role in the history of Impressionism, the most cliché-ridden movement in art's entire history. The root of the problem resides in a search for modern art's origins. Candidates for the role of prime innovator in this story have been Delacroix, Courbet and Manet, but in recent times writers have tended to agree that Manet best fits the bill as painting's modernist primogenitor. This is not the place to examine the precise nature of what makes modern art modern as opposed to merely contemporary. However, Manet's career will make more sense if we consider the quest for modernity in nineteenth-century French art. For, as we will discover in reviewing his career, Manet, like many of his contemporaries, sought to adapt his art to the changing conditions of life in Paris, the city which Walter Benjamin characterized as the capital of the nineteenth century *par excellence*.

The French Revolution gave dramatic impetus to the celebration of contemporary history. However, the art of the Revolution largely relied on Neoclassical style to provide a vehicle for presenting ideal images of a new society. Similarly, heroic battle pictures inspired by the Napoleonic armies tended to degenerate into a repertoire of contrived propagandistic rhetoric. The Bourbon Restoration of 1815 encouraged more innovative imagery that addressed the complexities of contemporary social and political life, but when Realism emerged in literature and the arts in the 1830s, it found itself at odds with a set of firmly established rules according to which art imitated nature through a process of

2 Edouard Manet
Lola de Valence, 1862
Oil on canvas, 123 × 92 cm
Paris, Musée d'Orsay

Lola Melea, known as Lola de Valence, was the star of Mariano Camprubi's Spanish ballet, which performed in Paris at the Hippodrome during the autumn of 1862. The picture inspired these lines from Baudelaire:

Entre tant de beautés que partout on peut voir,
Je comprends bien, amis, que le Désir balance;
Mais on voit scintiller dans Lola de Valence
Le charme inattendu d'un bijou rose et noir.

Amongst so many beauties everywhere to be
 seen,
My friends, how well I understand Desire's
 hesitation;
But Lola de Valence enjoys the illumination,
The unexpected charm of a pink and black gem.

The picture encapsulates a certain image of the alluring, exotic Spanish woman, but escapes from cliché by its individualized solidity, and the play on the gaudy skirt.

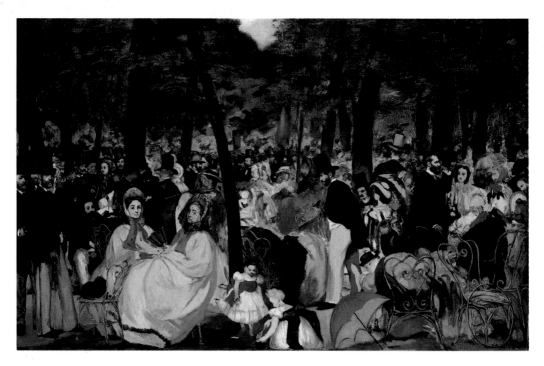

idealization. Art's edifying narratives and pleasing abstractions were expected to inhabit a timeless zone. Realism was controversial because it deviated from this tenet of bourgeois common sense.

The artist who made the most uncompromising contribution to finding a modern subject matter for Realism was Gustave Courbet (1819–77). Courbet chose to make paintings of provincial life (*Burial at Ornans*, 1850), the peasantry and the most menial activities (*The stonebreakers*, 1849). His deliberate choice of subjects conventionally regarded as beneath the scope of art, and his coarse application of paint, stemmed from a determined individuality and a sharp sense of what would strike a discordant political chord. Courbet and his followers did not, however, address city life with any consistency or success.

In the first half of the nineteenth century, Paris was changing so much that, apart from its major landmarks, it hardly offered a stable

3 Edouard Manet
Music in the Tuileries, signed and dated 1862,
Oil on canvas, 76 × 118 cm
London, National Gallery
The Palace of the Tuileries stood to the west of the Louvre, bordering the east side of the present Place de la Concorde. Napoleon III held court there during the Second Empire, and the concerts given in the gardens twice a week were frequented by fashionable society. According to his friend Antonin Proust, Manet would lunch at the café Tortoni before going to the Tuileries, and return there in the early evening to "accept compliments on his sketches". The picture is almost entirely made up of portraits, including that of Manet himself on the left edge, Zacharie Astruc seated to his left (our right), Baudelaire silhouetted against the tree trunk, and immediately to his left, the painter Fantin-Latour (see detail).

Detail of 3

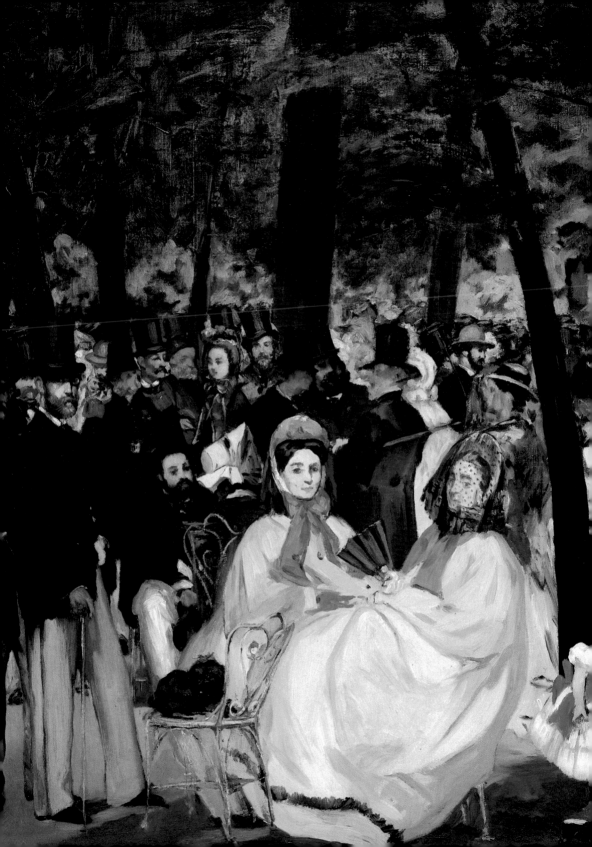

subject. Paris's population was continually swollen by new immigrants from the provinces in search of work, careers and success. From the middle of the century onward, major changes to the fabric of the city were afoot. Large boulevards were cut through the heart of the city. Many of the dilapidated winding streets that had grown up in its center were cleared out; new suburbs were created to the west. Street lighting and public transport contributed to the opening up of spaces shared by all classes. Politicians, journalists, writers, and artists were not well equipped to make sense of this jumbled concourse of socially diverse people. Attempts to find a modern mode of expression for art looked away from this disconcerting spectacle towards the more reassuring domain of the countryside and the safer *terra cognita* of bourgeois domesticity.

By the 1840s, however, the complex spectacle of Parisian life was coming into focus as worthy of the attention of novelists and artists. One of the most influential essays to review the possible modern urban subjects suitable for art was Baudelaire's article, *The Painter of Modern Life*, first published in 1863 but probably written several years previously. Baudelaire had already explored some of the essay's themes in an 1846 Paris Salon review where he had written of "the heroism of modern life." His comments are directly relevant to our understanding of Manet's approach to subject matter since the two men were closely associated in the 1860s. The importance of such critical advocacy of modernity in creating a sympathetic climate for the work of artists like Manet cannot be underestimated. As we will see, even with such support, Manet faced an uphill struggle in achieving widespread critical recognition.

"All forms of beauty," wrote Baudelaire in 1846, "contain an element of the eternal and an element of the ephemeral . . . Absolute and

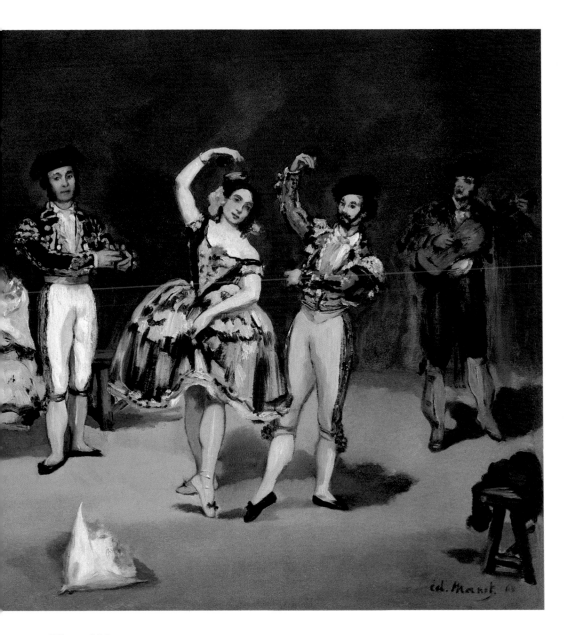

4 Edouard Manet
The Spanish ballet, 1862

Oil on canvas, 61 × 90.5 cm Washington, The Phillips Collection

This small painting shows Camprubi's Spanish ballet troupe, including Lola de Valence (2), seated to the left; Camprubi stands posed on the right with Anita Montez. It sits perhaps uncomfortably between being a group portrait and a scene of the dancers in performance. Manet had the dancers pose as if in performance, in Alfred Stevens's studio, which was larger than his own.

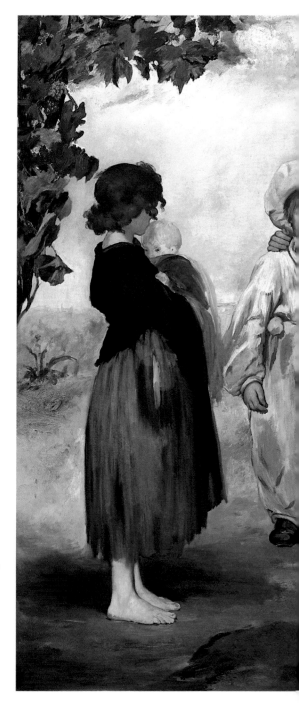

5 Edouard Manet
The old musician, 1862

Oil on canvas, 188 × 248 cm
Washington, National Gallery of Art

Manet has assembled on this canvas a motley
collection of figures to create a modern
equivalent of the well-known genre pictures of
beggars by Spanish seventeenth-century
painters such as Velázquez and Ribera. He has
included an echo of Watteau in the Pierrot-like
child, and of his own *Ragpicker*. An interest in
urban low life preoccupied nineteenth-century
writers and artists such as Baudelaire and Doré.

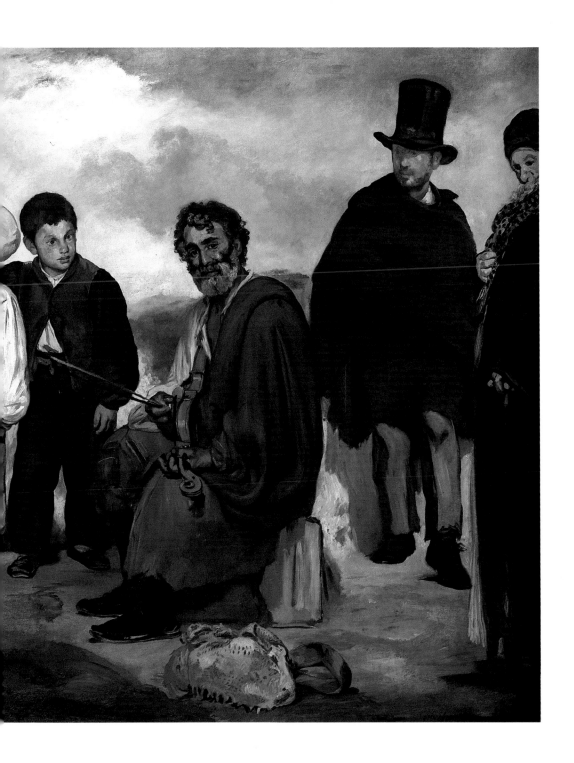

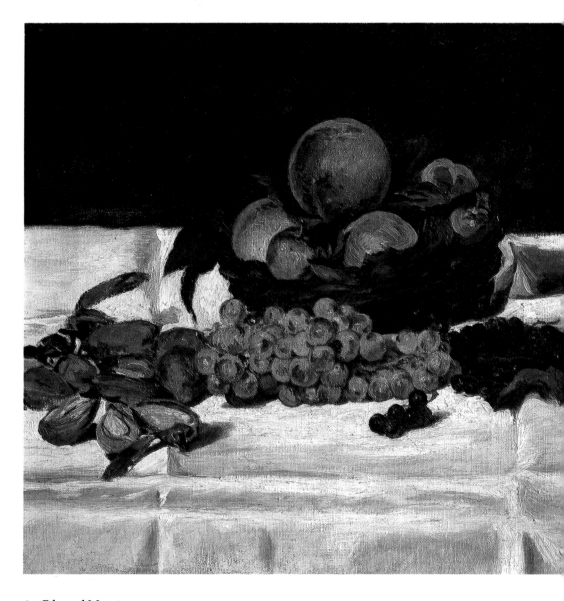

6　Edouard Manet

Fruits on a table, 1864

Oil on canvas, 45 × 73.5 cm
Paris, Musée d'Orsay

While this sparcely composed still life inevitably recalls the precedent of Chardin, its sombre coloring hints at Manet's absorption in Spanish painting. Manet's sustained predeliction for still-life painting providing him with a small-scale vehicle for exercises in the control of color and tone without the problematic obligation to offer some comprehensible narrative dimension encountered in his traditional and modern history paintings.

eternal beauty does not exist, or rather it is only an abstraction skimmed from the general surface of different beauties. The particular element in each manifestation comes from the emotions; and just as we have our own particular emotions, so we have our own beauty". Putting this belief into pictorial practice, however, was not straightforward.

The single class that dominated Paris in the mid-nineteenth century were bourgeois men, uniformly dressed in their black frock coats and trousers. It was habitual to decry this uninspiring form of dress as impossible for artists, but it reminded Baudelaire of a nation of mourners, lending dignity to the otherwise anonymous crowd. Dress—or "the outward husk of the modern hero"—was crucially important for streetwise observers like Baudelaire, for contained in it were clues to class, status, profession, and psychological disposition. Baudelaire proposed a wider scope and a more penetrating gaze for artists surveying the city for subjects than would have been plausible to most artists expecting to exhibit at the Salon.

"The majority of artists who have attacked modern life have contented themselves with public and official subjects—with our victories and our political heroism... However, there are private subjects which are more heroic than these... The pageant of fashionable life and the thousands of floating existences—criminals and kept women—which drift about in the underworld of the city; the *Gazette des Tribunaux* and the *Moniteur* all prove to us that we have only to open our eyes to recognize heroism."

Yet, to the dismay of later art historians, when Baudelaire identifies the painter of modern life in the title of his essay, it is not Manet, but Constantin Guys (1802–92), a draftsman and watercolor specialist who produced hundreds of small studies of fashionable

society of Second Empire Paris. It might be a sign of the modernity of Baudelaire's outlook that he turned to an artist who worked in a minor genre; perhaps it was a symptom of his loss of faith in modern painting on a large, ambitious scale: his enduring artistic hero was the aging Romantic Delacroix, who was to die in 1863. When he sought to reassure Manet after the bad press *Olympia* received (see below), Baudelaire rather witheringly offered Manet the consoling observation that he was, after all, "only the first in the decrepitude of your art." It is hard to construe this remark in a positive light, although, for chroniclers of the rise of modern art, it invitingly gives to Manet, in Baudelaire's privileged eyes, a leading role in the invention of modernism. Perhaps it is best added to the collection of unsolved puzzles in and around Manet's art which add to its fascination.

Manet's early career

Edouard Manet was born on January 23, 1832 in the center of Paris in what is today the rue Bonaparte. Within sight of his first home stood the Ecole des Beaux-Arts, where a memorial exhibition of his works was to be held in January 1884, after his untimely death the previous April at the age of fifty-one. He was the son of the chief of staff of the Ministry of Defense and of the daughter of a French diplomat. In 1849, after he had refused to study law, and had failed twice to get into the Navy, his father agreed to his studying painting. By the later part of the nineteenth century, despite the fanciful images propagated by books such as Henri Mürger's *La Vie de Bohème*, painting was a profession not unworthy of a well-groomed bourgeois such as Manet—a pursuit capable,

7 Edouard Manet
Dead Christ with Angels, 1864 Salon
Watercolour, gouache, 179 × 150 cm
New York, Metropolitan Museum
Whatever the ambiguities of *Olympia*, this picture confirms Manet's desire in the 1860s to establish himself as a history painter. Religious subjects were at the core of history painting's repertoire. Like the *Déjeuner sur l'herbe* (13), and *Olympia* (14), it has a nude at its center, but the episode is timeless rather than contemporary. Christ's mortality is offset by two angels, who here are given conventional robes and naturalistically feathered wings. Zola admired Manet's "cadaver freely and vigorously painted in a strong light."

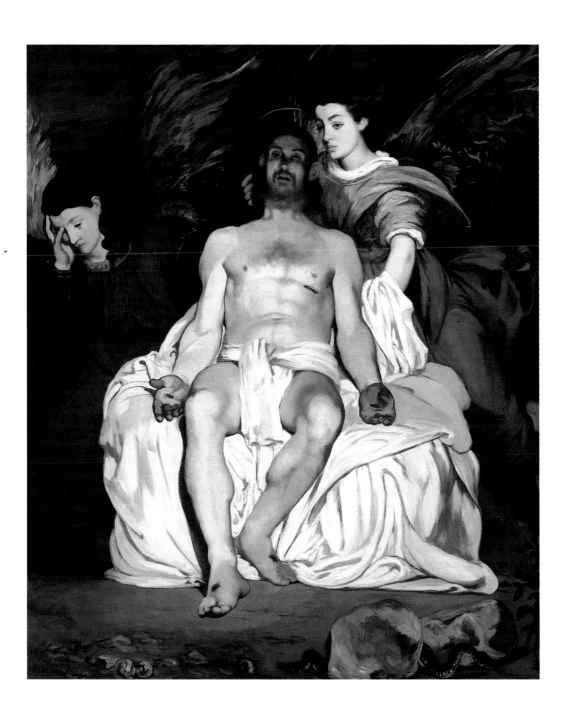

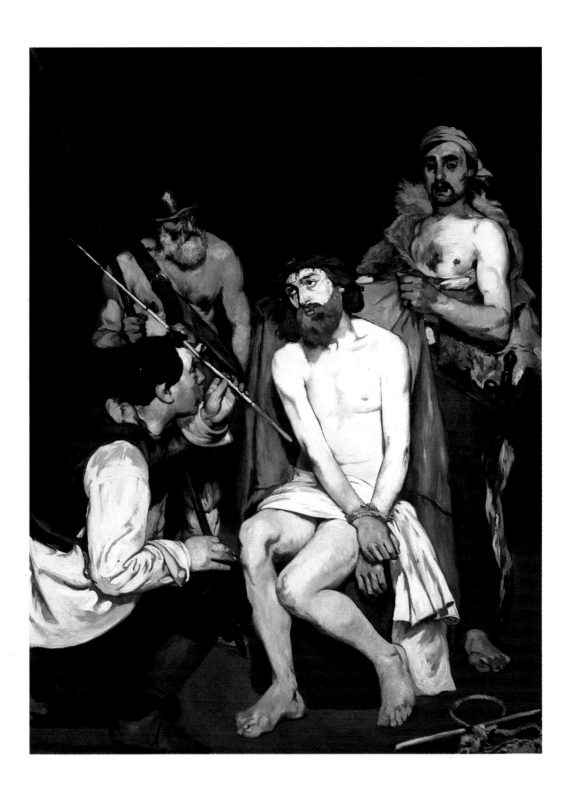

even, of leading to official honors and wealth. Manet never had serious money problems, but, to his enduring chagrin, he was slow to achieve any degree of official recognition.

He entered the studio of Thomas Couture, where he was to spend six years. Couture had recently established himself as a *chef d'école* with his huge *grande machine, The Romans of the Decadence* (1847 Salon; Musée d'Orsay). From Couture, Manet picked up the practice of making a very idiosyncratic kind of painted sketch, using the brush to draw soft, zig-zag lines. This was to develop into a characteristic painterliness, apparently nonchalant, but achieved only as a result of painstaking reworking. At the same time, he went through much of a history painter's traditional training: drawing and painting from the model, copying old and modern masters. In 1853 he visited Italy, as a serious painter was expected to do, to study old master paintings, and in 1856 travelled to Holland (where he copied Rembrandt's *Anatomy lesson*), Germany, Austria, and again to Italy (when he made a small copy of Titian's *Venus of Urbino*, which was to be important in the genesis of *Olympia* (**14**)). In 1859, he began work on a large painting of *The Finding of Moses* that he never completed. In July of the same year he registered as a copyist at the Louvre.

Manet's ideas on art were in tune with the broad aims of Realism, with its central idea that art should be "of its own time". The alternative, repudiated by Realism, was to make pictures of historic periods, which could never be as relevant and comprehensible as contemporary subjects. Realist subject matter was predominantly rural. Instead of nymphs and classical shepherds, it depicted country life. However, it took the abrasive examples of Jean-François Millet and Gustave Courbet to draw attention to the fact that the Italian peasants and Breton maids who populated

8 Edouard Manet
Christ mocked by soldiers, 1864–65 (1865 Salon)
Oil on canvas, 190.8 × 148.3 cm
Chicago, Art Institute

This is another essay in the synthesis of historic styles. Echoes of Van Dyck and Titian are unmistakable. The painting also has a Spanish flavor—the ochre tones, the soldiers' physiognomies and the dark background. It was the last religious subject Manet ever exhibited.

rural pictures during the first half of the century were more decorative than documentary. Manet was a descendant of Realism in the sense that he, too, wished to make art out of contemporary life, but his subject was late nineteenth-century Paris, not the life of the fields.

Though reluctant to confine his paintings to the historical and religious themes which were the staple diet of serious painting, Manet had also to confront the fact that traditional types of subject were more likely to find favor with the jury at the annual Salon exhibitions, and he was not to abandon such pictures for wholly contemporary subjects until the end of the 1860s. Indeed, it could be convincingly argued that throughout his career he continued to produce modernized and abbreviated history paintings. His approach to selecting subjects remained that of an artist steeped in the established conventions of history painting. Essentially, this adds up to choosing a significant moment in a narrative and making it the focus of the picture's composition, articulated through the interaction of expressively posed figures. The term history painting also has a double meaning in that it implies both concern for historical subjects and an emphasis on narrative. A hierarchy of types of painting existed according to their degree of focus on the human figure: still life was at the bottom, portraits and "genre" pic-

9 Edouard Manet
Portrait of Zacharie Astruc, 1866

Oil on canvas, 90 × 116 cm
Bremen, Kunsthalle

Zacharie Astruc (1835–1907) was an intimate friend of Manet. He wrote the verse for the 1865 Salon catalogue entry for *Olympia*, and introduced Manet to his enthusiasm for Spanish and Japanese art. The scene to the left of Astruc probably represents a painting, modelled on the background of Titian's *Venus of Urbino*, a point of reference for *Olympia*.

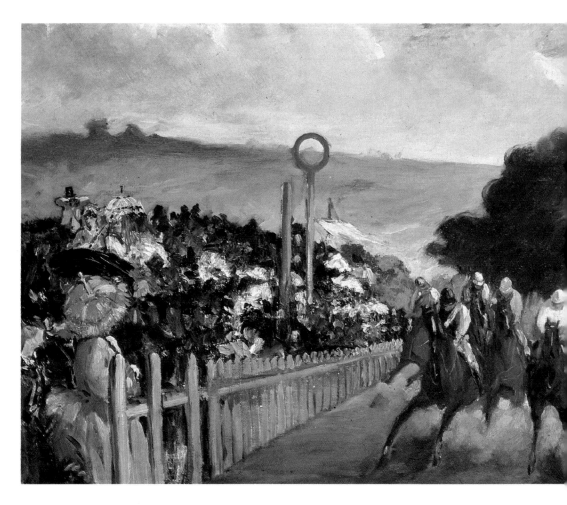

10 Edouard Manet
The races at Longchamp, 1864
Oil on canvas, 43.9 × 84.5 cm
Chicago, Art Institute, Potter Palmer Collection

The Longchamp racecourse is in the Bois de
Boulogne, to the west of Paris. The picture is
unusual in Manet's work in capturing speed
and movement, and innovative in the history of
pictures of horseracing in adopting a head-on
viewpoint.

tures (sometimes translated as "pictures of everyday life") came in between, and "history painting" at the top. These categories were not fusty academic dogma, but built into the structure of artistic practice and public expectations alike throughout the nineteenth century. Whatever the variety of other types of painting he was later to produce, at the outset of his career Manet went to great time and trouble to succeed as a history painter. Accordingly, we find him producing *The surprised nymph* (1859–61), *Dead Christ with Angels* (1864) (**7**), and *Christ mocked by soldiers* (1864–65) (**8**). Manet's two most infamous paintings, *The picnic* (otherwise known as *Le Déjeuner sur l'herbe*) (**13**) and *Olympia* (**14**), uneasily combine tradition and contemporaneity. However, as his confidence in himself as a painter grew, his choice of up-to-date subjects—from the *Execution of Maximilian* (**11**) to *The escape of Rochefort* (**33**) and his portrait of *Clemenceau at the Tribune* — became an increasingly personal, and more partisan, manifestation of his Republican sympathies. Yet the transition from working through imitations of old masters to making his paintings distinctively individual was a slow one. Moreover, this is perhaps a false distinction, for, to take only these three examples: the *Maximilian* is based on a Goya, the *Rochefort* on a Delacroix, the *Clemenceau* on portraits of French revolutionary orators.

In 1861, Manet not only had his first works accepted at the Salon—*Portrait of M. and Mme. Manet* and *The Spanish singer* (Metropolitan Museum, New York)—but also received an "honorable mention." The "Salon" was an annual state-sponsored exhibition, held each spring in the Palais de l'Industrie on the Champs Elysées. Submissions were selected by a jury of artists. It was the high point of the art calendar and could lead to public commissions. Each year around one

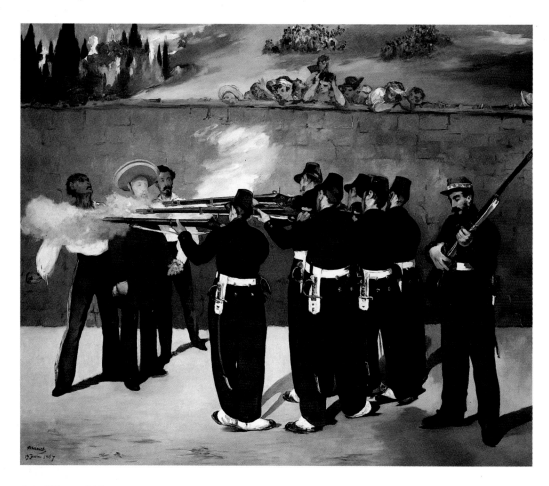

11 Edouard Manet
The execution of Maximilian, 1868

Oil on canvas, 252 × 305 cm
Mannheim, Städtische Kunsthalle

Maximilian of Austria, Emperor of Mexico, was executed by the followers of Juárez on June 19, 1867 with Generals Miramón and Mejía. Napoleon III had installed Maximilian as Emperor, but failed to provide the necessary miltary support to maintain his rule. In its derivation from Goya's *Third of May* 1808 (1815), which Manet had seen in the Prado two years earlier, its reliance on photographs and press reports, and in its polemical intent, the picture represents an attempt to give life to modern history painting. The difficulties inherent in this aim are evident in the fact that, despite going through several versions, the project remained incomplete.

Detail of 11

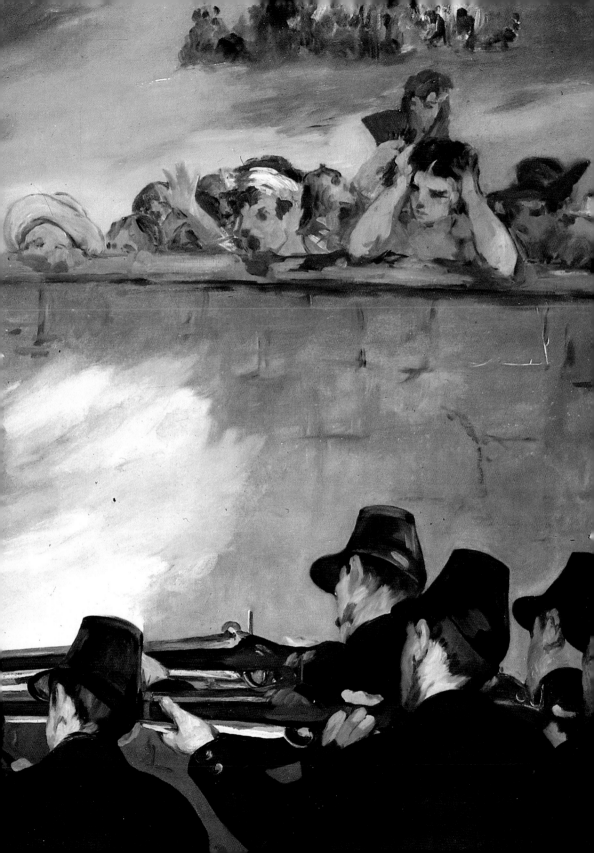

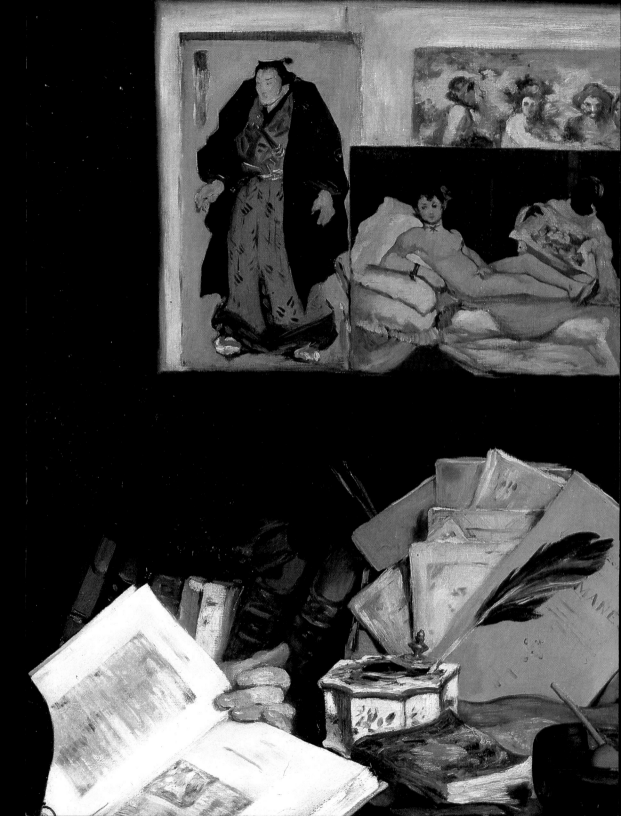

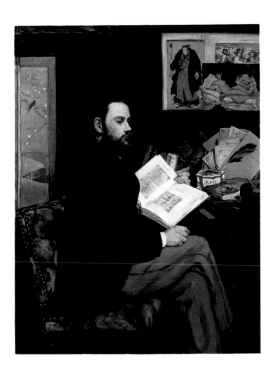

12 Edouard Manet
Portrait of Emile Zola, 1868 (1869 Salon)
Oil on canvas, 146 × 114 cm
Paris, Musée d'Orsay
**The novelist and journalist Emile Zola
consistently defended Manet in his art
criticism. This portrait is an homage to his ally.
Zola's 1867 pamphlet extolling Manet's virtues
sits behind the inkpot on the desk. A
photograph or print of *Olympia*, a print after
Velázquez's *Los borrachos* and a Japanese print
are framed above the desk as tokens of Zola's
and Manet's interests.**

Detail of 12

hundred reviews of the exhibition were pub-
lished, ranging from the serious to the silly.
Manet had the misfortune to become identi-
fied as one of those artists whose paintings
were easy to mock. It would be a mistake to
infer from unsympathetic press response that
Manet set out to provoke either the Salon
audience or the critics. Quite the reverse.
Manet himself took reviews seriously: in 1870
he challenged Edmond Duranty to a duel
(which he won) because he took exception to
his article in *Paris-Journal*.

Nonetheless, Manet was not without
eloquent and influential supporters in the
press. Throughout Manet's career many of his
friends were writers: poets, journalists, novel-
ists. Several actively supported him by writ-
ing enthusiastic reviews of his work. Emile
Zola, whom he first met in 1866, regularly
praised his paintings, and also wrote a pamph-
let explaining the sincerity and qualities of
Manet's work. Zola's claim that "Manet's
place in the Louvre is marked like that of
Courbet" was as alarming as it was reassuring,
for Courbet had been the most controversial
French artist in recent times. For Zola, taking
up the art critical cause of Manet was a means
of advertising his own prowess as a polemical
journalist. Other critics, such as Baudelaire,
privately encouraged Manet when his Salon
exhibits received a bad press. It was with
Baudelaire that Manet attended Delacroix's
funeral in August 1863. From the time of their
meeting in 1874, the poet Stéphane Mallarmé
was an almost daily visitor to Manet's studio.
Manet illustrated some of his poems and also
his translation of Poe's *The Raven*. Mallarmé's
subtle prose gave a further dimension to the
body of writing on Manet's paintings. How-
ever appealing these associations are, it would
be far too simple to seek to explain Manet's
work by means of equating it with the ideas of
any one of these, or any other writers.

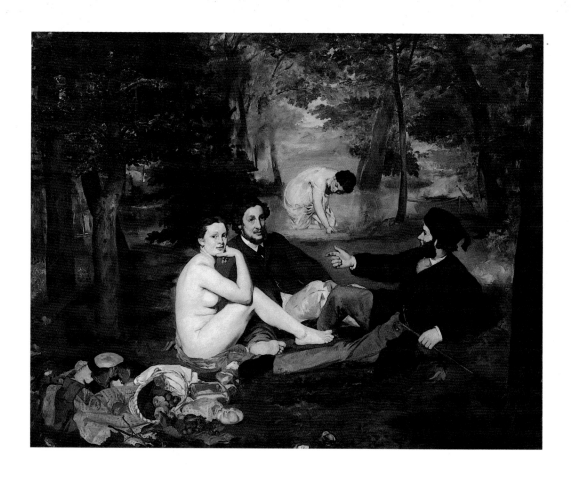

The *Déjeuner sur l'herbe* and *Olympia*

Manet's career received a setback in 1863, for *Le Déjeuner sur l'herbe* (The picnic) (**13**) and two other pictures on Spanish themes were consigned to the "Salon des Refusés." After his initial success in 1861, the *Déjeuner*, a large, ambitious painting, should have set the seal on a successful début. Such hopes were emphatically shattered not only by this ignominious rejection—which classed his pictures with genuinely inept art amongst the "Refusés"— but by the unsympathetic critical reception for which his exhibits were singled out.

13 Edouard Manet
Le Déjeuner sur l'herbe (**The picnic**) 1863
Oil on canvas, 208 × 264 cm
Paris, Musée d'Orsay

At the Salon des Refusés in 1863 the picture was entitled *The bath*. *The picnic* treats a banal subject in a serious manner and on a large scale. It was a composition contrived in the studio and was not an early example of open air painting. At least as discomforting as the absence of an obvious subject is the insertion of the brightly lit nude into a shady clearing.

Detail of 13

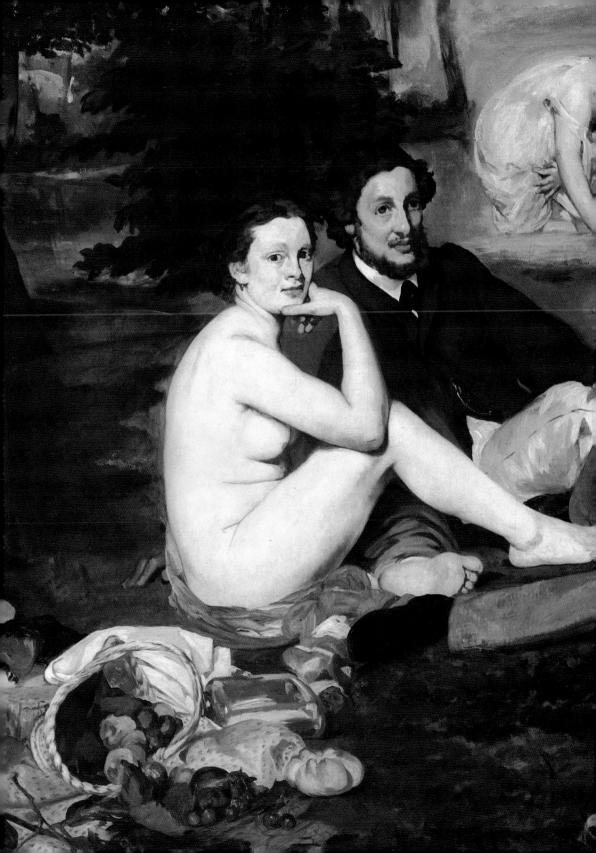

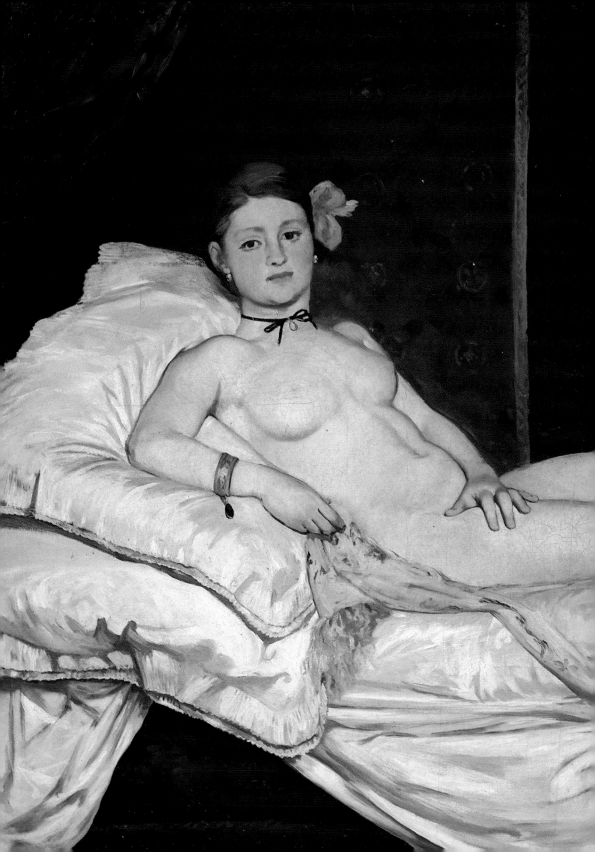

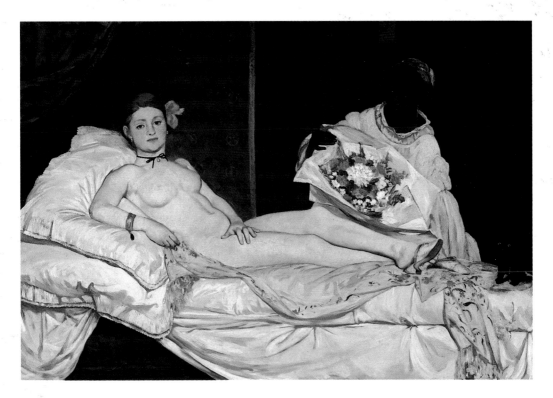

14 Edouard Manet
Olympia, 1863
Oil on canvas, 130.5 × 190 cm
Paris, Musée d'Orsay

After the bad reception given to the *Déjeuner* (13), Manet decided not to submit *Olympia* to the 1864 Salon; it was, however, accepted in 1865. The ambiguous ingredients of mythology, realism, and irony were echoed by Zacharie Astruc's poem, printed in the catalogue:

Quand, lasse de songer, Olympia s'éveille,
Le printemps entre au bras du doux messager
 noir
C'est l'esclave à la nuit amoureuse pareille,
Qui veut fêter le jour délicieux à voir,
L'auguste jeune fille en qui la flamme veille.

When, weary of dreaming, Olympia awakes,
A sweet dark messenger enters bearing Spring
 in her arms.
It is the slave who like amorous night
Comes to celebrate the delicious day,

The majestic maiden who keeps the flame
 alight.

Olympia's slippers, bracelet, hair ribbon, neck band and the shawl she lies on all anchor her body in the realm of the naked rather than the nude. The cat, servant and her reclining mistress have the air of the photographic *tableaux vivants* that were produced during this period in imitation of narrative paintings.

In *Le Déjeuner sur l'herbe* (1863) and *Olympia* (1864) (**14**), Manet sought to combine the language of traditional history painting with the appeal and relevance of a contemporary theme (we should remember that *Olympia* was accompanied at the Salon by *Christ mocked* (**8**)). At one and the same time, both pictures are unequivocally contemporary in their dress and setting, and also explicitly draw on old master paintings. The *Déjeuner* borrows from a print after a Raphael composition, and echoes Titian's *Concert champêtre* in the Louvre, in its combination of nude women and fully clothed men. *Olympia* adapts Titian's *Venus of Urbino*, and claims for itself a place in the venerable tradition of the reclining female nude that included Rubens, Velázquez (Rokeby *Venus*), Goya (clothed and naked *Majas*), Ingres (*Odalisque*) and David (stretching the definition of "nude" to include the lightly attired *Madame Recamier*). In this way, Manet signaled his knowledge and emulation of respected forebears.

Manet puts the female nude center stage in both pictures, but refuses to idealize. Zola was later to write that Manet had "violated the Temple of the Ideal." Both pictures also sinned in aspects of decorum. Although it seems too contrived to be genuinely offensive, the *Déjeuner* shows a naked woman surrounded

15 Edouard Manet
Luncheon in the studio, 1868 (1869 Salon)
Oil on canvas, 118 × 153.9 cm
Munich, Bayerische Staatsgemäldesammlungen

Swords and armor suggest the paraphernalia of an artist's studio. The man sits smoking behind a table laden with the ingredients of a Dutch still life—lemon, oysters, glass. The picture contains an element of portraiture in that the young man is Manet's illegitimate son, Léon Leenhoff. Irrespective of the inconsequential subject, the picture is one of Manet's most seamless essays in tonal harmony.

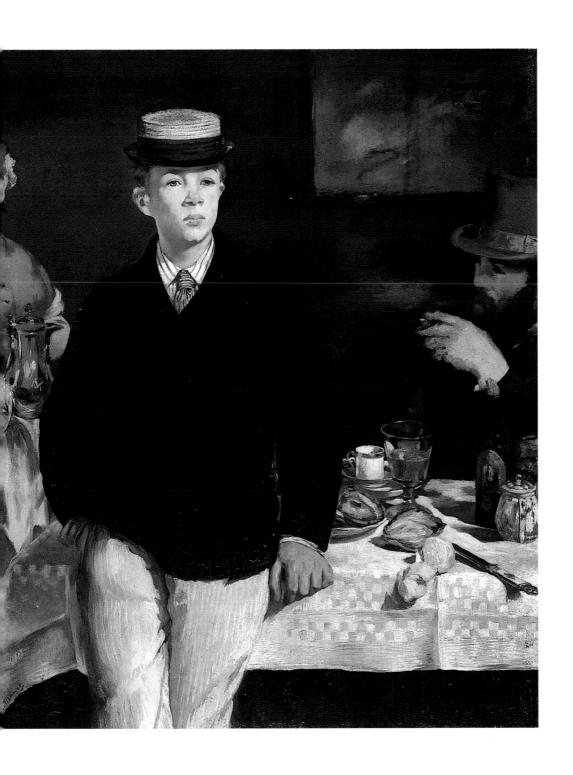

33

by two fully clothed men while another woman, dressed only in a shift, is washing herself behind them. *Olympia* is a picture of a prostitute in an idiom indebted to Baudelaire—the black servant, the black cat, the aroma of blank-faced moral *laissez-aller*. This was hardly innovative. Nineteenth-century art and literature abound in stories about the equivocal figure of the fallen woman and prostitute. Whether in the form of the glittering kept women of the nobility and plutocracy, or the tawdry banality of the bro-thel, prostitution was an ubiquitous facet of urban life. When Second Empire Parisians visted the Salon, however, they preferred images of courtesans to be distanced through exoticism or historicism. The more art fic-tionalized eroticism, the more easily it could be consumed without guilt. Nothing elicited the wrath of the nineteenth-century bour-geois more than being confronted with the contradictions of his own hypocrisy. Almost nobody seems to have appreciated Manet's particular fusion of seriousness and irony. Indeed, most twentieth-century commenta-tors have sought to rescue the picture by means of praising its purely painterly qua-lities, at the cost of an almost unanimous silence concerning why Manet chose to make a picture about a prostitute.

There is no single fact that can explain the picture. Very little of what Manet himself said about the picture has been recorded, and what we know is not very illuminating. He rebuffed the claim that he had fired off a metaphoric revolver close to the spectator's ear, adding: "I render, as simply as can be, the things I see."

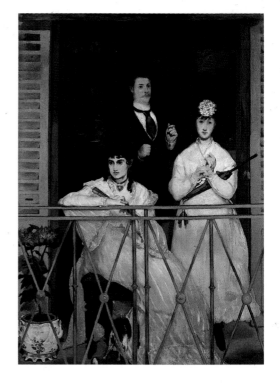

16 Edouard Manet
The balcony, 1868 (1869 Salon)
Oil on canvas, 169 × 125 cm
Paris, Musée d'Orsay

Once again, Manet has redefined a model taken from Goya. In place of *majas* on a balcony, attentive and on display, we see three figures smartly attired as if for an outing, but disengaged from any social context.

Detail of 16

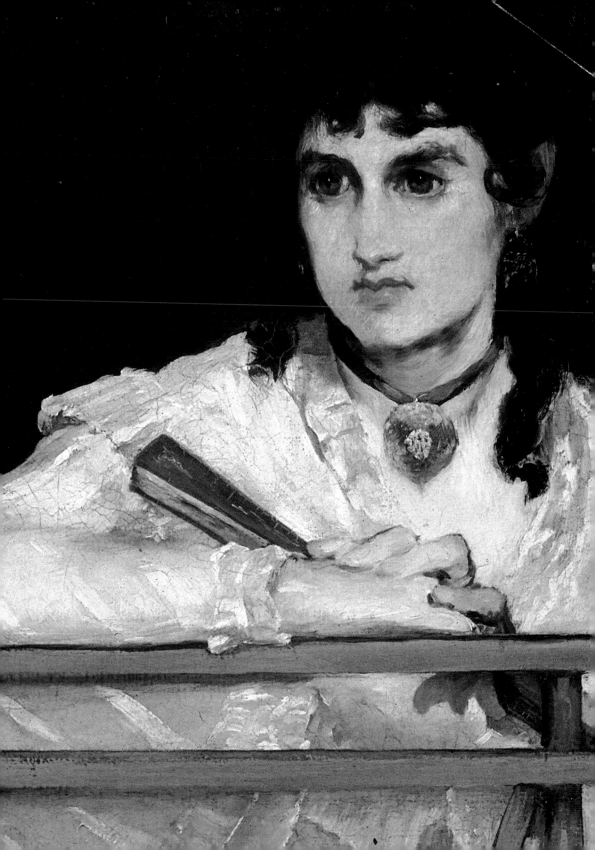

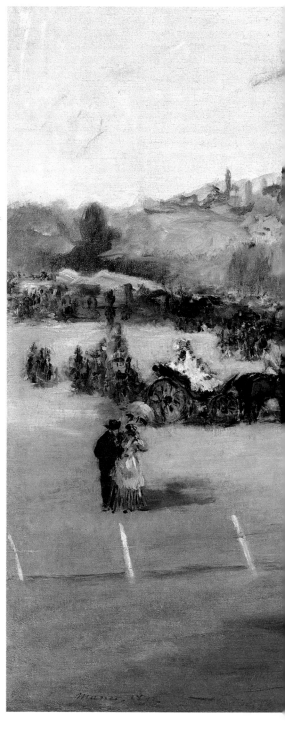

17 Edouard Manet
The barricade, 1871?
Lithograph, 46.5 × 33.4 cm
Boston, Museum of Fine Arts

The print shows Communards being executed by French government troops after the collapse of the Commune in May 1871, a scene that Manet probably saw on his return with his family to Paris from the provinces. The firing squad motif is reused from *The execution of Maximilian* (11).

18 Edouard Manet
The races at the Bois de Boulogne, 1872
Oil on canvas, 73 × 92 cm
New York, Mrs John Hay Whitney collection

Manet's racing scenes are reminiscent of Degas's images of the same milieu. Yet here Manet persists in depicting galloping horses in an old-fashioned, flat-bellied posture, in contrast to his own more modern *The races at Longchamp*.(10).

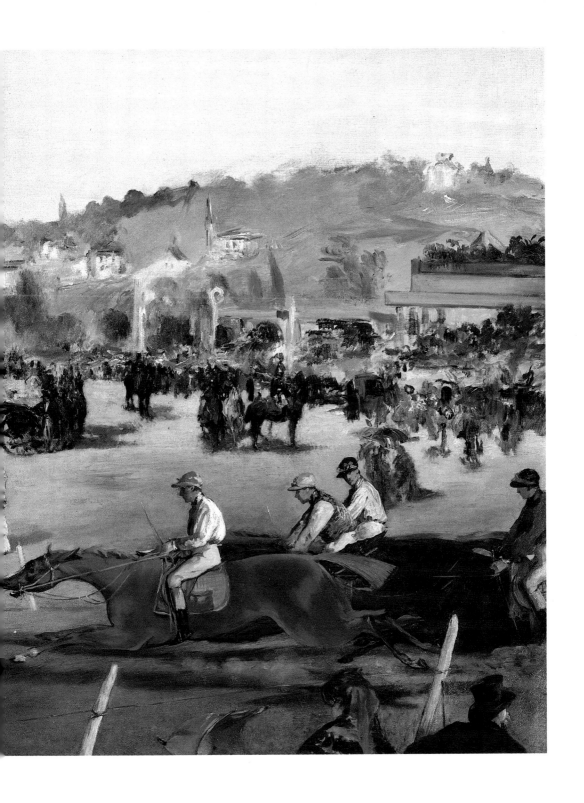

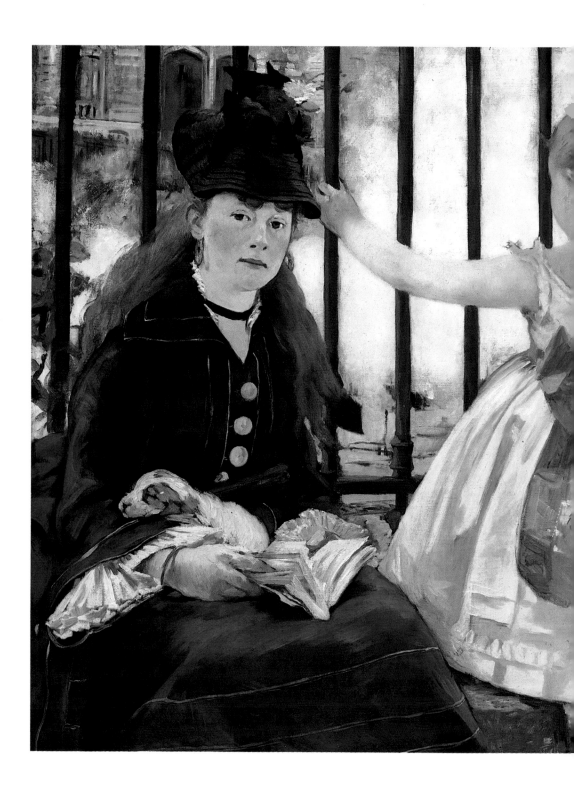

Manet and Spain

In the autumn of 1865, Manet left Paris for a trip to Spain. His itinerary had been planned by Zacharie Astruc and took in Burgos, Vallodolid, Toledo—where he saw paintings by El Greco—and Madrid, where the Prado museum housed incomparable collections of Velázquez, Goya, and Titian. Like a previous generation enamored of Romanticism, he was attracted to the real-life models for Goya's scenes of bullfights, *majas*, and picturesque low life—a world of violence and sensuality re-created in Prosper Mérimée's *Carmen*. A letter from Manet to Fantin-Latour reveals how his attention was divided: "Madrid is a pleasant city, full of diversions. The Prado is a charming promenade, full of pretty women, all in mantillas, which gives it a very original look. In the streets there are all sorts of costumes, and toreadors, who themselves have a strange form of town wear." But he was just as deeply drawn to the courtly art of Velázquez. He was to write that the whole journey had been worthwhile if only for having seen Velázquez's work. Manet wrote in admiration of "the painter of painters. He has astounded and delighted me." Everything by Velázquez he saw in the Prado was for him a masterpiece. The refined elegance of seventeenth-century Spanish nobles appealed to the Parisian Second Empire dandy. Like Manet, Velázquez always aspired to the

19 Edouard Manet
The railway, 1872–73
Oil on canvas, 93 × 114 cm
Washington, National Gallery of Art
The railings divide a garden from the line coming from the Gare St-Lazare. A woman, sleeping dog, and young girl confront the noisy spectacle of the railway with an impassive elegance typical of Manet's figures.

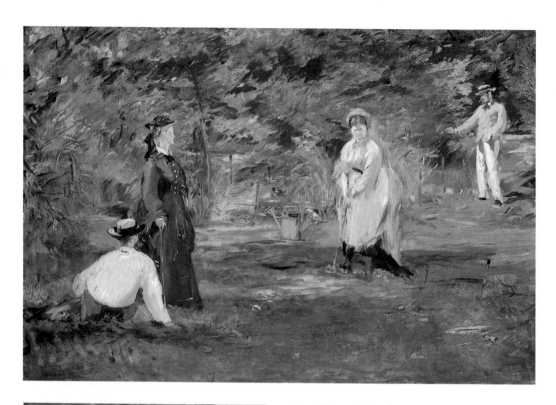

20 Edouard Manet
The croquet game, 1873
Oil on canvas, 72.5 × 106 cm
Frankfurt, Städelsches Kunstinstitut
The reduced scale of the figures and the
enclosure of the scene by foliage, broken up by
dappled light, recall contemporary
Impressionist paintings by Monet and Renoir.

Detail of 20

21 Edouard Manet
The artist, 1875
Oil on canvas, 192 × 128 cm
Sao Paolo, Museu de Arte
Marcellin Desboutin (1823–1902) was a painter
and etcher associated with Impressionist
circles. He is perhaps most famous for having
posed for Degas's *L'Absinthe*. The sombre
coloring, the hunting dog and Desboutin's
black attire evoke Frans Hals and Velázquez.

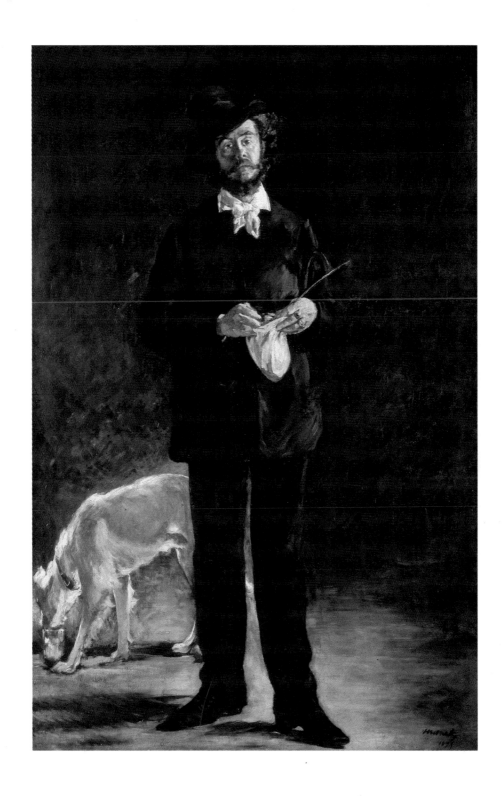

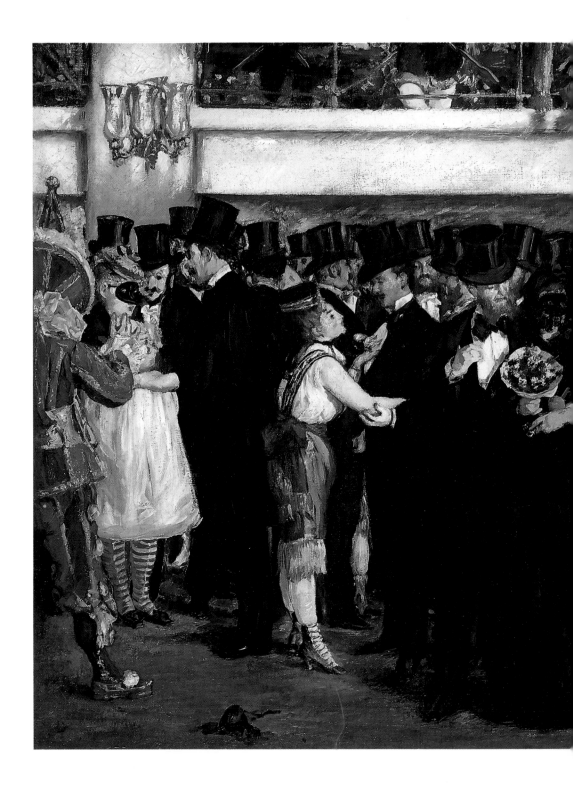

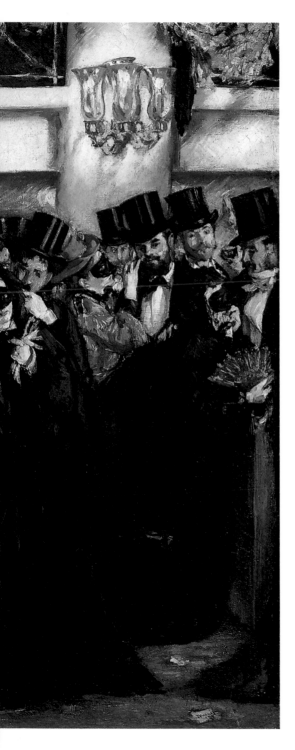

utmost painterly economy. Manet was to make painted copies and prints after several of Velázquez's pictures.

Pictures such as *The old musician* (**5**) are directly modelled on seventeenth-century Spanish genre scenes. While Manet might have turned to Dutch and Flemish examples when producing such pictures of beggars, vagrants, and street life, Spanish art offered a richer, more sympathetic vein of painterliness compared to the meticulous detail of Northern art. In his addiction to rich blacks and grays, and the placing of single figures against a featureless background, Manet adopts unmistakable Velázquez traits. This enthusiasm was relatively novel. Spanish art had effectively been first discovered by the French during the Napoleonic wars. Access to Spanish paintings was considerably enhanced by the establishment of a "Galerie Espagnole" in the Louvre, which showed works by Goya and Velázquez and others during the 1830s and 1840s.

Manet considered both Velázquez and Goya to have been artistic witnesses to their own times, as he wished to be for nineteenth-century Paris. Manet's problem was how to translate the spectacle of the modern city into the idiom of high art, or as Baudelaire ironically put it, how to capture "the heroism of modern life." Manet's experience with the *Déjeuner* and *Olympia* discouraged further

22 Edouard Manet
Masked ball at the Opéra with Punchinello,
1873–74
Oil on canvas, 60 × 73 cm
Washington, National Gallery of Art

The Opéra's masked ball took place in Lent. Unlike the tea-time stroll evoked in *Music in the Tuileries* (3), the ball was not a family occasion. The masked women, some dancers, some working-class party girls, were there to be picked up by the undisguised men.

experiments with the nude, perhaps thankfully so, for he was never much at home with abstractions. Manet's painting is, in an important sense, a quintessential manifestation of bourgeois materialism. It is an art of surface. His meticulous observation of nuances of dress and fashion was an extension of the Parisian need to read people's identity through their clothes, and of the fact that fashions changed rapidly, creating a hierarchy based on expendability of materials and fabrication. Critics acknowledged that Manet attended closely to textures and patterns, but complained that he painted faces in the same manner as he painted fabrics, for they expected the human figure to be given more careful treatment, and therefore accused Manet of indifference. Throughout his career, he always worked from the model, and, as his sitters recounted, he did so doggedly and painstakingly. All Manet's pictures are compilations of studies made from the life. For the *Bar at the Folies-Bergère* (**31**), he set up bottles on a marble slab; for his Spanish pictures he borrowed costumes; for his *Portrait of M. Pertuiset, the lion hunter*, Pertuiset was posed with his gun in the studio, as was the lion skin separately, and the landscape was based on Pertuiset's garden. Something of Manet's patience indubitably rubbed off on his painting. The mesmerizing presence of Manet's paintings is as irresistible as it is inexplicable.

Despite the rebuff given to *Olympia*, Manet resolutely submitted works to the next Salon in 1866. Both his submissions (*The fifer* and *The tragic actor*) were rejected. Zola's defense of Manet in the press led to their meeting. At the same time, Manet also met Monet, partly as a consequence of their names having been confused at the Salon.

Although Manet never left the Salon entirely, he also at times invited the public into his studio and exhibited work in commercial galleries, particularly the Galerie Martinet, and later the Galerie Durand-Ruel—one of the early outlets for Impressionist painting. In 1872, Durand-Ruel bought twenty-four paintings from Manet. At the time of the Exposition Universelle in 1867, Manet took the exceptional step of arranging a separate one-man show of fifty pictures in the garden of the Marquis de Pomereux. In this, he was following the earlier example of Courbet, who had set up his own pavilion in 1855 as a challenge to the International Exhibition, and did the same in 1867. The preface to the catalogue was written by Manet with the assistance of Astruc and explained the simple rationale behind the exhibition: "Since 1861, Monsieur Manet has been exhibiting, or trying to exhibit. This year he has decided to show his works as a whole to the public directly." An article by Zola published in January was republished as a brochure with a portrait of Manet and a print of *Olympia*. Discouraged by the bad press which the exhibition received, he left Paris to visit Boulogne and Trouville.

The next three Salons (1868–70) were moderately successful for Manet in that he had two paintings accepted at each. But the Franco-Prussian war (1870–71) and its sequel, the Paris Commune, severely disrupted French cultural life until the summer of 1871. Manet sent his family to safety in the southwest of France and enlisted. After the defeat of the French army, he rejoined his family in February 1871, and they travelled back to Paris together, only to enter the city during the bloody suppression of the Commune, as French government troops massacred the Communards. In the autumn of 1871, Manet retired to Boulogne to repair his health. In the summer of 1872, he visited the new Frans Hals museum in Haarlem and the Rijksmuseum in Amsterdam.

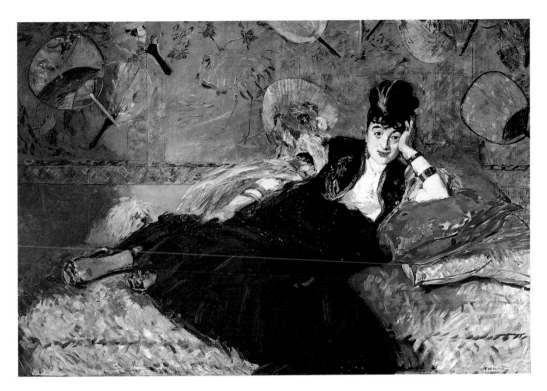

23 Edouard Manet
Lady with fan: Portrait of Nina de Callias, 1873–74
Oil on canvas, 113 × 166 cm
Paris, Musée d'Orsay

Manet was an habitué of the literary and artistic salon held by
Nina de Callias. Dressed in Algerian costume, reclining on a sofa
against a background decorated with Japanese fans, Nina de
Callias's blasé but commanding gaze gives to her portrait a
highly personalized presence, despite the fact that the
composition relies on the tradition of the passive odalisque.

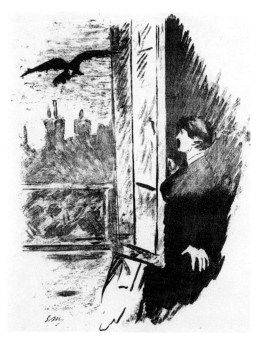

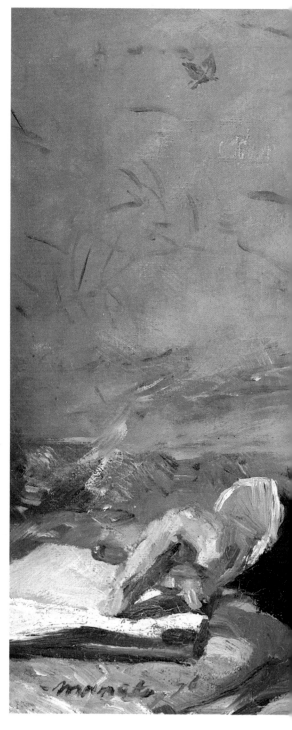

24 Edouard Manet
"Open here I flung the shutter..."
From *The Raven*, by Edgar Allen Poe, translated
by Stéphane Mallarmé, 1875
Lithograph, 38.5 × 30 cm
Paris, Bibliothéque Nationale

The idea that Manet eschewed pictorial
narrative is belied by his dazzling suite of
illustrations for Poe's haunting poems. The
image is also a good example of Manet's
graphic facility. In Manet's art, the distinction
between drawing and the fluid tonality of oil
painting becomes increasingly blurred.

25 Edouard Manet
Stéphane Mallarmé, 1876
Oil on canvas, 27 × 36 cm
Paris, Musée d'Orsay

The poet Stéphane Mallarmé was one of the
most eloquent commentators on Manet's work
in his own lifetime. As he reclines in front of a
Japanese hanging, Mallarmé's hand rests on
blank sheets of paper, holding not a pen, but a
cigar, as a token of material comfort and inner
reflection.

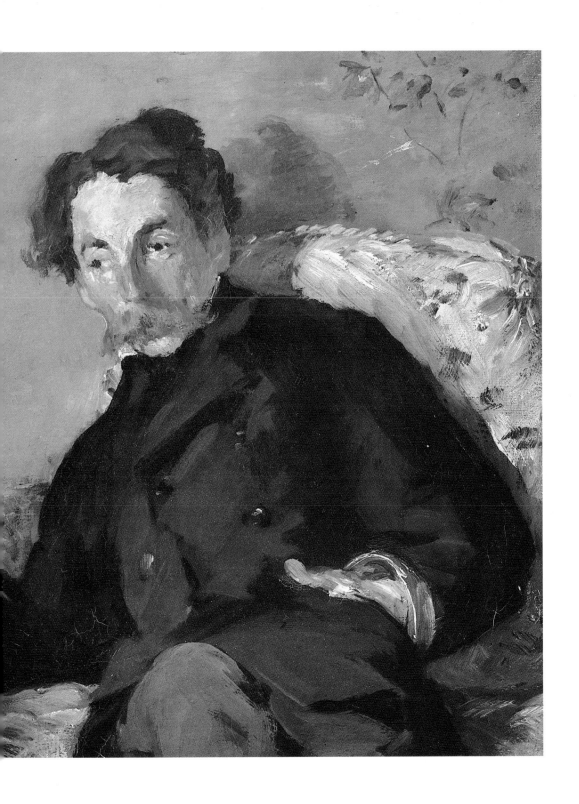

Impressionism

The 1874 Salon opened on April 12. That year Manet had two pictures accepted, the watercolor *Polichinelle* and an oil painting, *The railway* (**19**). A little over a month later, on May 15, another exhibition opened on the Boulevard des Capucines in the photographer Nadar's premises. Organized by the "Société anonyme des artistes, peintres, sculpteurs, graveurs," this was the first of what were later to become known as the "Impressionist" exhibitions. Manet had been invited to participate, but had not accepted and, indeed, was never to exhibit with them. That he has become inseparably identified not only with Impressionism, but with "the Impressionists", is significantly misleading. Three points should be emphasized to clarify the situation. First the idea for an independent exhibition was far from revolutionary; such occasional exhibitions had been organized for many decades. It was essentially an attempt to give a small number of artists a chance to have their work seen in less crowded conditions than in the Salon, where over two thousand works large and small vied for attention. Secondly, there was no neat and tidy Impressionist group with an acknowledged leader. If we consult contemporary writings, there is not even a consensus as to what "Impressionism" was; all that is clear is

26 Edouard Manet
Claude Monet and his wife in his floating studio,
1874
Oil on canvas, 80 × 98 cm
Munich, Neue Pinakothek
Claude Monet had transformed a boat into a floating studio on which to make open-air paintings at Argenteuil. It is characteristic of Manet that he focuses on figures rather than landscape.

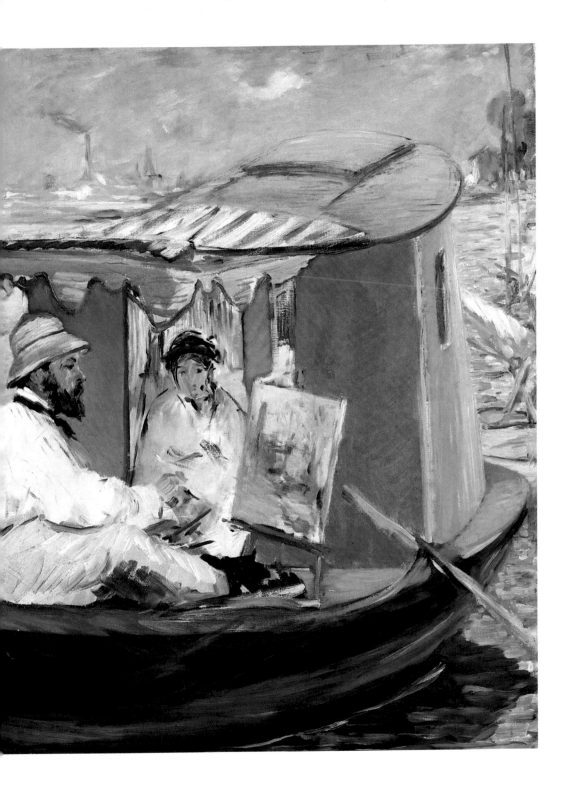

27 Edouard Manet
Argenteuil, 1874 (1875 Salon)
Oil on canvas, 149 × 115 cm
Tournai, Musée des Beaux-Arts

Despite the picture's suggestion of relaxation and leisure, the couple retain their bourgeois stolidity, detached from the summer atmosphere, and from any company. Argenteuil was a suburb to the west of Paris. This is one of the first pictures which Manet painted largely out of doors.

Detail of 27

that it was not until the 1880s that it became a commonly used label. Ideas about the significance of Impressionism were most fully stated during the 1880s by artists who were interested in pursuing other concepts of painting. Thirdly, while Manet knew most of the artists concerned, was on friendly terms with them, and gave them practical support when possible, he by no means wholeheartedly identified with their artistic aims and practice.

Manet's painting only partially absorbed the kind of open-air painting propounded most passionately by Monet. During the 1870s he gave considerable attention to landscape and outdoor painting; in 1874, he painted with Monet and Renoir at Argenteuil. Compared to the pictures they produced on this occasion, which break the scene down into flickering areas of dappled light, dissolving figures and contours, Manet's *Argenteuil* (**27**) is solid, and almost conventional in its framing of a couple sitting posed in front of the river. It was only partly executed in the open air. The prime vehicle for Impressionist experiment was landscape, and Manet was by training and by nature a figure painter. His attempts to paint landscapes tended to coincide with the Manet family's summer holidays. Trips to the coast were facilitated by the new railway lines. Between 1870 and 1872, Manet had a view of the lines coming out of the Gare St-Lazare (where *The railway* (**19**) is set) from a studio on the rue St-Pétersbourg.

Much Impressionist painting is engaged with the public spaces of Paris—streets, parks, cafés, theaters—and related leisure activities. In this respect, Manet's work undoubtedly overlaps with Impressionist themes. His friend Antonin Proust argued that one of Manet's most important activities which indirectly fueled his art was strolling around Paris, observing and noting details of people's dress and posture, and this new

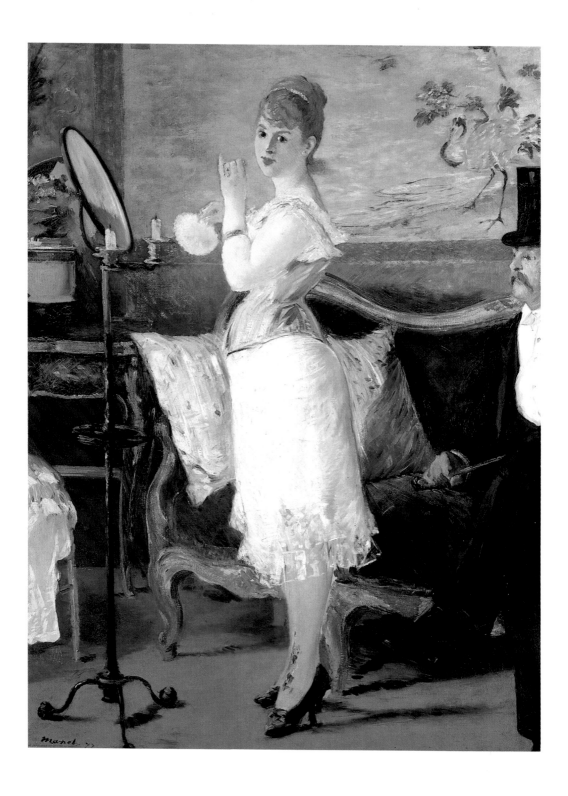

28 Edouard Manet
Nana, 1877
Oil on canvas, 154 × 115 cm
Hamburg, Kunsthalle

This is an example of the
literary and artistic
representation of the
courtesan which
proliferated under the
Second Empire to form a
distinct genre. The
picture's title was drawn
from Zola's novel
L'Assommoir (1876) but
predates Zola's later
novel called *Nana*.
Making sense of the
connotations of the
picture is complicated by
the fact that the model
for the figure of Nana
was Henriette Hausen, a
young actress who, like
Manet, frequented Nina
de Callias's salon. Nana's
direct gaze and her
emphatic centrality
invite the spectator to
view the seated male
figure in a sceptical,
almost comic, light.

29 Edouard Manet
The plum, 1877–78
Oil on canvas, 73.6 × 50.2 cm
Washington, National Gallery
of Art

The unlit cigarette and
unsipped brandy may
signify the woman's
state of introspection.
But since Parisian cafés
were places of male
socializing, to be an
unaccompanied woman
in a café was usually an
invitation for attention.

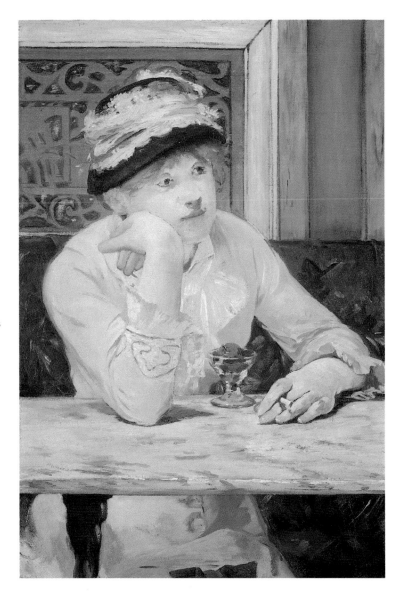

attention given to the social fabric of the city was characteristic of much Impressionist imagery. The critic Théodore Duret said of Manet that he was a Parisian who ultimately was only at home in Paris. Of the Impressionist artists, he had most in common with Degas, another inveterate *flâneur* (idler). Although he did not share Degas's obsession with the female nude, during the 1870s Manet did produce a series of pictures of women dressing, washing, or simply posing, which are very similar to such studies by Degas. They both depicted the racecourse (**10**, **18**), the *café-concert* (**31**), bourgeois portraits and interiors, the Opéra. Yet, by the 1880s, the individual artists who converged in the Impressionist exhibitions were quite clearly following different paths. As Manet died in 1883, how his art would have evolved is an open question.

Final years

The range of Manet's work produced in the 1880s before his death suggests no particular direction. *The escape of Rochefort* (1880–81) (**33**) reaffirms his desire to tackle modern historical subjects. The *Portrait of M. Pertuiset, the lion hunter* (1880–81) is a puzzling picture in its tongue-in-cheek theatricality—Pertuiset poses with a double-barreled shotgun and a lion skin—and is made all the more so by its size; it is the largest picture he painted after the *Execution of Maxi-*

30 Edouard Manet
Man in a café, **1878**
Oil on canvas, **64.5 × 81.5 cm**
Boston, Isabella Stewart Gardner Museum
Cafés became alternatives to studies for men of letters and journalists. They were also ideal vantage points for observing the flux of city life on the streets and boulevards.

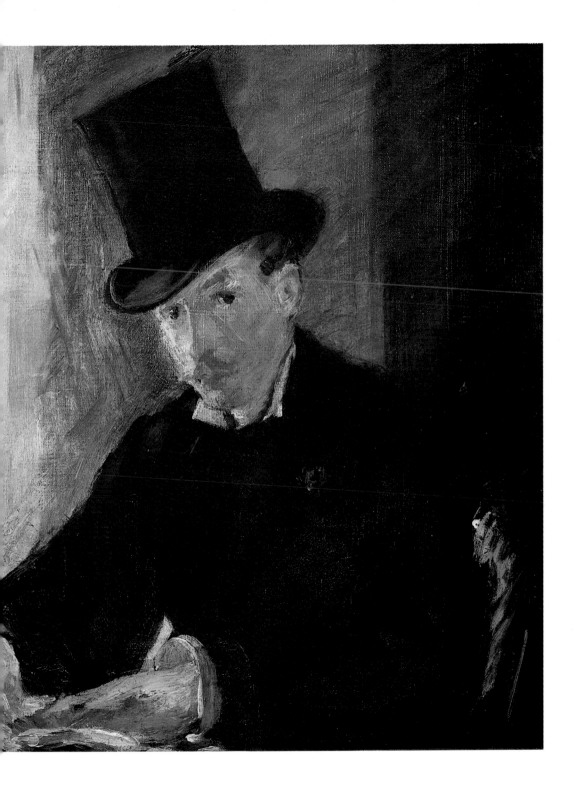

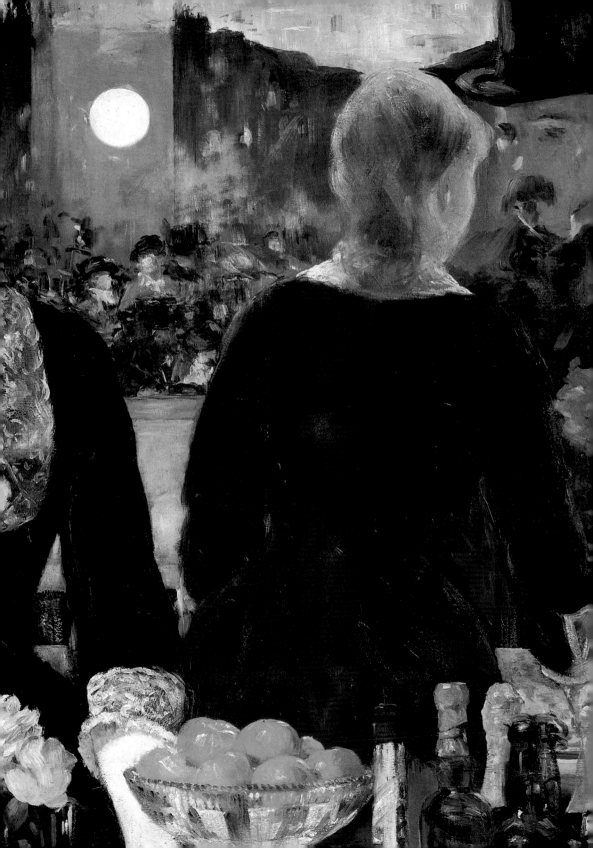

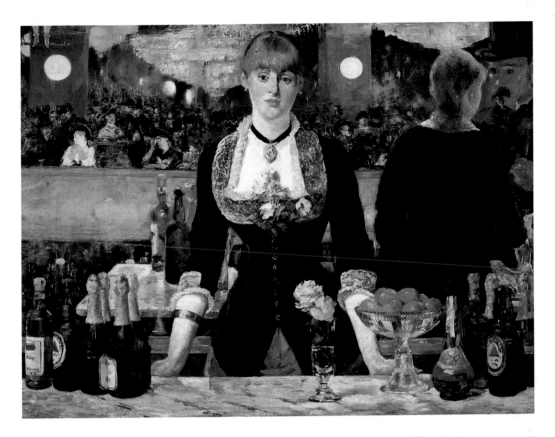

31 Edouard Manet
The bar at the Folies-Bergère, 1881–82

Oil on canvas, 96 × 130 cm
London, Courtauld Institute Galleries

Such pictures of bars—a commonplace in late nineteenth-century French art—were always painted in the studio, using models and assembled still lifes. The Folies-Bergère was a popular *café-concert*, as much a place to pick up women as of entertainment. The barmaid's expression is as likely to reflect the inertia of a model's pose as the decorative passivity of the available woman. The skewed angle of the mirror heightens the ambiguity.

Detail of 31

milian. The *Bar at the Folies-Bergère* (1881–82) (**31**) is the most elaborate work of his last years, eliding a single figure with the reflected background of chandelier and jostling crowds. He started a series of allegories of the seasons, commissioned by Antonin Proust, of which only *Spring* and *Autumn* were executed. These were half-length figure studies of impeccably dressed women friends.

The political consolidation of the Third Republic starting in 1871 saw a wave of refitting and decorating town halls and civic buildings with imagery appropriate to the new Republican ideology. As a consequence, monumental painting was given a new lease of life. Manet considered himself a candidate for such commissions. On April 10, 1879, he wrote to the Prefect of the Seine outlining his

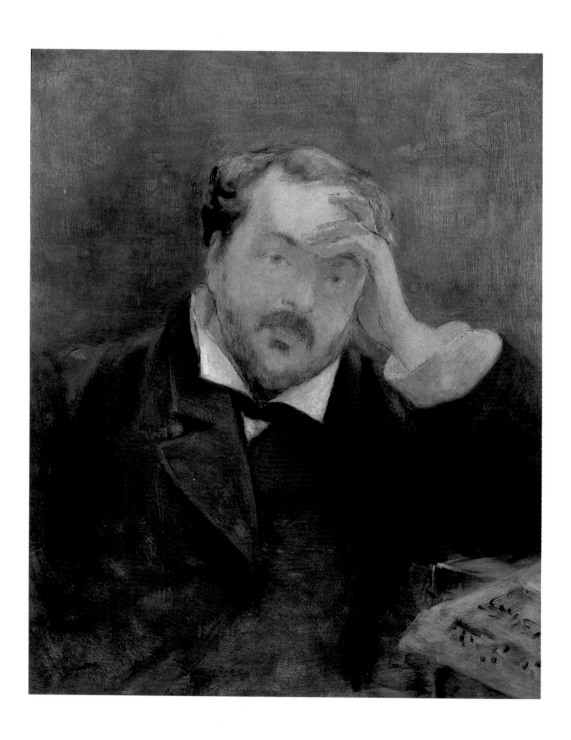

plan for redecorating the Municipal Council Hall of the new Town Hall (the old one had been gutted by fire at the end of the Commune): "a series of compositions representing, to use an expression now hackneyed but suited to my meaning, 'the belly of Paris,' with the various bodies politic moving in their elements, the public and commercial life of our time. I would have Paris Markets, Paris Railways, Paris Port, Paris Underground, Paris Race-courses and Gardens. For the ceiling, a gallery around which would range, in suitable activities, all those men who, in the civic sphere, have contributed or are contributing to the greatness and the riches of Paris." It is not easy to imagine the types of painting that might have resulted since Manet never completed anything larger than moderate-size history paintings such as the *Déjeuner* and *Olympia*. When he spoke to Antonin Proust of this project he mentioned the possibility of using allegory to represent the wines of France. But he also emphasized the need for images of contemporary Frenchmen which would convey to later generations the truth of things "as they were," as he believed Dutch art had done for seventeenth-century Holland.

In 1881, at the age of forty-nine, Manet's two exhibits at the Salon—portraits of Pertuiset and Rochefort—won him a second-place medal and future immunity from the jury. Through Antonin Proust's new position as Minister for Fine Arts, he was made Chevalier de la Légion d'Honneur. Freed from the ordeal of having to submit his works to the jury, he sent the *Bar at the Folies-Bergère* (**31**) and *Spring* to the 1882 Salon. From April 1883, he was bedridden. Manet died on April 30, ten days after the amputation of his gangrenous left leg. He was buried in Passy cemetery.

32 Edouard Manet
Portrait of Emmanuel Chabrier, **1881**

Oil on canvas, 65 × 45 cm
Cambridge MA, Fogg Art Museum

The composer Emmanuel Chabrier was a close friend of Manet's. They shared an interest in Spanish culture. Of all contemporary French composers, Chabrier's music is probably the most analogous to Impressionist painting, in its lightly touched pictorialism.

Posthumous reputation

Manet had little direct impact on contemporary artists. He was revered by his admirers as a inimitable independent whose work had been cruelly misjudged by the majority of his contemporaries. His death did nothing to accelerate widespread acceptance of his work. In 1889 Claude Monet was behind a subscription to prevent *Olympia* being sold to an American by Manet's family. The picture was given to the nation and consigned initially to the Musée du Luxembourg, since works could only be considered for the Louvre ten years after an artist's death. Although *Olympia* was transferred to the Louvre in 1893, it was not put on show right away. Even nearly thirty years after its first exhibition, it was still controversial. Finally, in 1907, it was displayed in a room also containing Ingres's *Odalisque*, but it continued to cause discomfort. The episode found its way into Proust's *A la Recherche du temps perdu*. Oriane de Guermantes described her encounter with *Olympia* during a visit to the Louvre: "Nobody is astonished by it anymore," she recounted, but nonetheless confessed to doubts. "It doesn't quite belong in the Louvre."

Olympia proved to be the single picture by Manet most often reworked by later artists. Cézanne painted a number of pictures on the theme of *The modern Olympia*, which show a fully dressed man sitting before the naked woman. Gauguin copied it, and in 1901 Picasso made a drawing showing a black Olympia with a male servant and the artist sitting by the bed reaching out to touch the woman's body. Another controversial icon of modern art that took prostitution as its theme was Picasso's *Desmoiselles d'Avignon* (1907). Like *Olympia*, it was a work which provocatively challenged contemporaries' comprehension, opening the door to Cubism. Unlike

33 Edouard Manet
The escape of Rochefort, 1880–81
Oil on canvas, 146 × 116 cm
Zurich, Kunsthaus

Manet here attempts a modern history painting, allowing the sea, rather than any obvious narrative, to create atmosphere. The figure of Rochefort is singled out at the prow of the rowing boat. Henri de Rochefort (1830–1913) was an opposition polemicist during the Second Empire. After the collapse of the Commune, he was imprisoned and deported to New Caledonia, from where he escaped in 1874. After an amnesty in 1880, he became a radical socialist journalist.

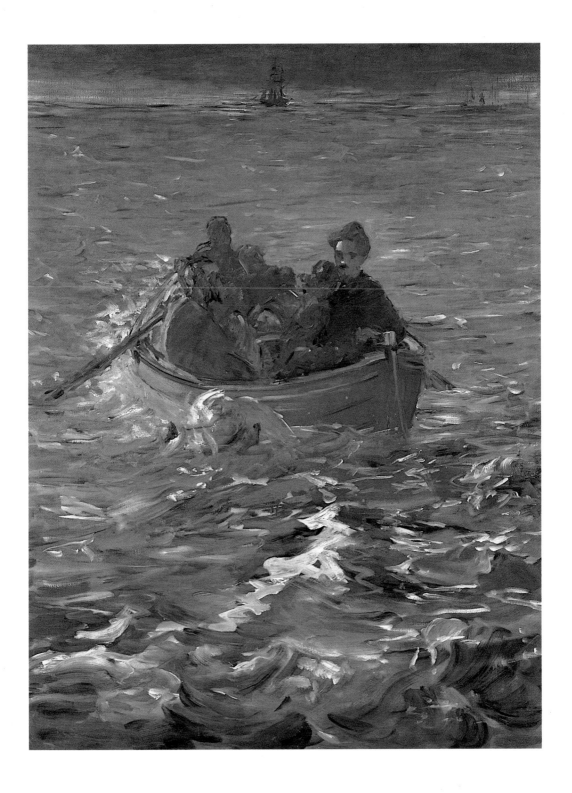

Manet's dedication to the Salon, however, Picasso made no attempt to court public approval and kept the picture in his studio: the twentieth-century Parisian avant-garde had turned its back on public attention.

Among the critics, the controversies Manet had attracted persisted, and his acceptance as a major artist was a slow process. Antonin Proust was the prime mover in arranging a retrospective exhibition and sale of the works owned by Manet's family that also included pictures lent by more than fifty private collectors. It required all his influence with the government of the day to ensure that this took place in the bastion of established artistic values, the Ecole des Beaux-Arts. The introduction to the catalogue was written by Zola, who managed to interweave equivocation with a resounding endorsement of Manet's stature.

"If you want an accurate realization of the great place which Manet occupies in our art, try and name someone after Ingres, Delacroix, and Courbet. Ingres remains the champion of our school of classical tragedy; Delacroix blazes throughout the Romantic period: then comes Courbet, a realist in his choice of subjects but classic in tone and execution, borrowing from the old masters their learned trade. Truly, after these great names I am not unaware of some fine talents who have left many works; only I am looking for an innovator, an artist who would have brought a new vision of nature, who would above all have profoundly changed

34 Edouard Manet
The house at Rueil, **1882**
Oil on canvas, 78 × 92 cm
Berlin, Nationalgalerie
Immobilized by the deteriorating condition of his left leg, Manet could be carried into the garden to paint. Rather than a spontaneous study this is a carefully composed picture for which several studies exist.

the artistic production of the school: and I am compelled to come to Manet, to this scandalous man so long disowned and whose influence is dominant today."

In the catalogue of the sale of Manet's studio contents which followed, Theodore Duret also attempted to define Manet's significance. Duret had been an articulate supporter of Impressionism, and he saw in Manet a kindred spirit who at the same time deserved full institutional recognition. Manet was above all an innovator, or as he termed it, an inventor—all the more admirable for having chosen a difficult route to success: "These are the men who have their own particular way of seeing and feeling and, if they are painters, a touch, a color, a way of drawing, which are absolutely their own. And nothing is easy for them. First of all they have to find themselves, they must succeed in giving form and expression to their obscure and turbulent visions." Duret's vision of such innovators is instructive, for he sees them not as a break-away group in the manner of modern avant-garde mavericks, but as part of a tradition embracing great artists of the past.

Financially, however, the sale was no more than a moderate success. Most significantly, the state failed to acquire anything. Manet had to wait over a generation to receive the highest accolade for a French artist—being exhibited in the Louvre. When Manet's works did start entering national collections in the early twentieth century, they came as a result of bequests, notably that of the *Déjeuner sur l'herbe* a year before *Olympia* was transferred from the Luxembourg to the Louvre. Manet's reputation was sealed in 1932, the centenary of his birth, when he was accorded a large retrospective in the Orangerie in the Tuileries gardens. Following the Second World War, a museum of Impressionism was created in the Jeu de Paume across the way from the Orangerie. Here *Olympia* and the *Déjeuner* hung together, symbolizing Manet's inspirational role in the history of Impressionism. If the Museum of Impressionism always seemed like a special outpost of the Louvre, its monumental successor, the Musée d'Orsay across the Seine, has come to be a rival to its older, more august neighbor. There Manet's major works are rightly situated amongst a survey of French art of the second half of the nineteenth century, rather than being isolated in the upper galleries which house the main Impressionist collection.

In tune with the greater historicism of this display, art history has devoted much energy to investigating the circumstances in which Manet produced his art. Putting aside the formalist kind of approach to Manet which had become part of received art historical wisdom, art historians have looked again in detail at Manet's choice of subjects. Contrary to the idea, much propounded by nineteenth-century critics such as Zola, that Manet's paintings strove to be no more than artfully arranged patches of pure tone, we are now able to look at them as part of a wider movement of ideas which could be called critical naturalism. That is to say that the works of Manet and some other Impressionist painters were highly selective in their choice of motif—surrounded by the flux of urban transformation, they could hardly have been otherwise. In its ambivalent engagement with contemporary life, their art constitutes the last phase of an attempt to combine the individual artist's subjectivity with the obligation to represent material reality. The following generation of Post-Impressionists, Symbolists and proponents of avant-garde art shifted their focus away from the external toward the deeply personal domain of the imagination and its elusive dynamism.